not a guide to

Jersey

Mark Brocklesby

First published 2012

The History Press
The Mill, Brimscombe Port
Stroud, Gloucestershire, GL5 2QG
www.thehistorypress.co.uk

British Library Cataloguing in Publication Data.
A catalogue record for this book is available from the British Library.

ISBN 978 0 7524 7150 1

Typesetting and origination by The History Press
Printed in Great Britain

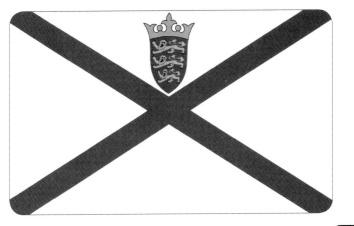

Jersey Flag

A red saltire on a white background.

*

In the upper quadrant is the badge of Jersey that comprises of a red shield with the historic three leopards of Normandy topped by a yellow Plantagenet crown.

Contents

Jersey

Nobody is quite sure where the name 'Jersey' originates, but is possibly Old Norse for 'Geirr's Island'.

The name 'Jersoi' was first mentioned in 1025.

It has been spelt over the last thousand years in various ways: Gersoi, Gerseie, Gersey, Jerseye, Jarzé, Gerzai, Gersui, and, finally, Jerzey.

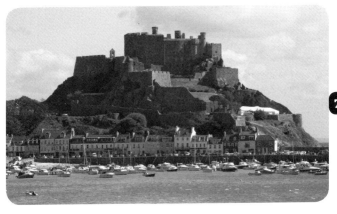

Geographic Coordinates

49°15″N, 2°10″W

9

Parishes

The island is divided into twelve administrative parishes, all of which have access to the sea.

St Helier – The capital of Jersey, containing roughly a third of the island's population. Contains the commercial port and ferry terminal, the much debated Waterfront development, Elizabeth Castle, Royal Square and the central market.

St Brelade – Has a sizable population focused around St Aubin's village and Le Quennevais, but also some of Jersey's favourite beaches. Sites of interest include the Fisherman's Chapel, with its medieval frescoes, and Corbière lighthouse.

St Clement – The smallest parish by surface area, but the second most densely populated. The rocky tidal zone that stretches along the parish coast is part of a UN RAMSAR site of special significance. Seymour Tower sits 2 miles offshore on one of the largest inter-tidal reefs in the world.

St John – Predominately rural with excellent cliff-path walks along the coast.

St Lawrence – Much of the parish is inland, although it has a short stretch of coastline along St Aubin's Bay. Interesting sights include Hamptonne Country Life Museum and the Jersey War Tunnels.

St Martin – St Martin has historic monuments from all periods of Jersey's history, including the dolmens of Le Couperon and Faldouet, Mont Orgueil Castle and St Catherine's Breakwater.

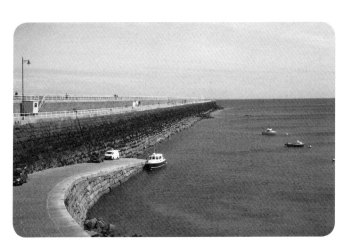

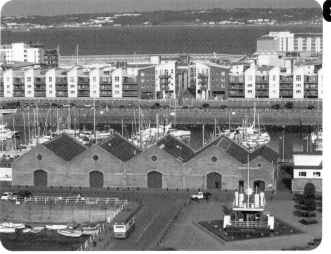

Grouville – The coast is the main oyster-producing area of Jersey. It is notable for La Hougue Bie, Gorey Village and Queen's Valley. The parish shares its patron saint with St Martin, and thus the church is officially named Saint Martin de Grouville.

St Mary – A rural parish with the smallest population. The coast has some of the best cliff paths on the island, with a good stopping point at Devil's Hole, a blowhole in the cliffs.

St Ouen – The largest parish by surface area. Historic sites include the ruins of Grosnez Castle and Le Pinacle.

St Peter – The only parish to have two separate coastlines. It is dominated by the airport, which opened in 1937.

St Saviour – A virtually landlocked parish, it only has access to a small piece of coastline at Le Dicq. Government House at the top of St Saviour's Hill is the official residence of the Lieutenant-Governor, the Queen's representative in Jersey.

Trinity – Trinity has the reputation of being the most rural of the parishes. It is home to Durrell Wildlife, the Eric Young Orchid Foundation and the Royal Jersey Showground, site of the Jersey Live music festival.

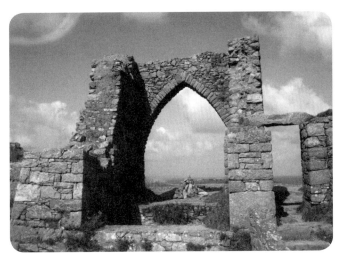

Street Names

La Rue Trousse Cotillion, 'Tuck up your Petticoat Street', was named for the filth thrown into St Helier's streets.

Five Mile Road, a colloquial name for La Grande Route de Mielles, stretches along much of St Ouen's Bay; the 5 miles actually refers to the length of the beach rather than the road.

Minden Place was named for a city in Germany where Jerseymen formed part of the British force that defeated the French on 1 August 1759.

Route du Nord was built during the German Occupation as part of a States scheme to provide employment for local men and is now dedicated to those who suffered during those years.

Victoria Avenue is the only stretch of dual carriageway in the Channel Islands. It was named for the Diamond Jubilee of Queen Victoria in 1895.

Georgetown was named for George Ingouville, who received a Victoria Cross in 1857 in recognition of his heroic actions during the Crimean war.

Les Quennevais, 'Hemp fields', references the hemp vital for making ropes when shipbuilding was a major Jersey industry.

La Pouquelaye, 'a place where fairies live'.

Colomberie was named after a dovecote that used to be here.

Mulcaster Street was named for Captain Mulcaster, who commanded Elizabeth Castle during the French invasion of 1781. When called upon to surrender he refused – and opened fire on the French troops.

The Tunnel, passing under Fort Regent, is 420 metres long.

La Rue de la Prison, now Charing Cross, was the site of the island's first prison, built in 1679.

Rue de la Pouclée et des Quatre Chemins is the longest road name on the island; it roughly translates as 'road of the four paths and dolmen'.

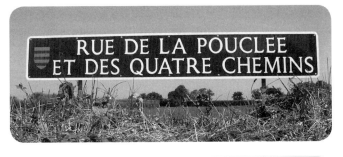

RUE DE LA POUCLEE
ET DES QUATRE CHEMINS

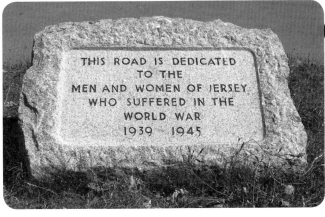

THIS ROAD IS DEDICATED
TO THE
MEN AND WOMEN OF JERSEY
WHO SUFFERED IN THE
WORLD WAR
1939 - 1945

Distance from...

Place	Km	Miles
Ayers Rock	15,253	9,478
Brussels	494	307
Centre of the Earth	6,370	3,958
Death Valley	8,477	5,268
Eiffel Tower	326	203
Frankfurt	1,218	757
Guernsey	44	27
Hong Kong	9,880	6,140
Isle of Man	583	362
Jerusalem	3,650	2,268
The Kremlin	2,743	1,705
London Eye	291	181
The Moon (average)	382,500	237,674
The North Pole	7,049	4,380
Osaka, Japan	9,785	6,080
The Panama Canal	8,335	5,179
Queenstown, SA	9,459	5,878
Reykjavik	2,035	1,265
The Sun (average)	152 million	94.5 million
Taj Mahal	7,281	4,524
Ural Mountains	4,120	2,560
Vatican City	1,391	864
Washington DC	5,842	3,630
Xanthi	2,282	1,418
Yellowstone National Park	7,400	4,598
Zurich	814	506

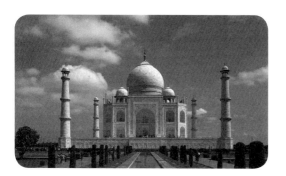

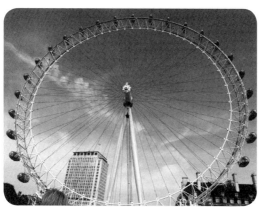

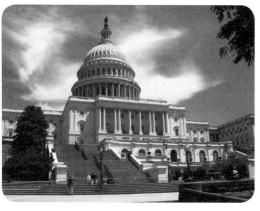

New Jersey

During the English Civil War, Jersey – led by its Bailiff, George de Carteret – remained loyal to the Crown and gave sanctuary to the Prince of Wales, who was crowned King Charles II in the Royal Square following the execution of his father.

As thanks for his loyalty, George de Carteret was given the land between the Hudson and Delaware Rivers in the nascent North American colonies, territory which would become New Jersey.

State bird – American goldfinch

State freshwater fish – brook trout

State dance – square dance

Motto – 'Liberty and prosperity'

Population – 8,8791,894 people (approx 98 times larger than Jersey)

Area – 8,721 square miles, or 22,608 square kilometres (approx 194 times larger than Jersey)

Famous for: Bruce Springsteen, Bon Jovi, The Jersey Devil, and television series *The Sopranos* and *Jersey Shore*.

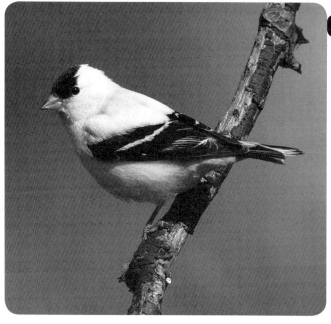

Parish Twinnings

St Helier – Bad Wurzach, Germany

St Helier – Funchal, Maderia

St Helier – Avranches, Normandy

St Brelade – Granville, Normandy

St Ouen – Coutances, Normandy

St Clement – Cancale, Brittany

Trinity – Agon Coutainville, Normandy

St Saviour – Villedieu les Poêles, Normandy

Grouville – Portbail, Normandy

St John – Le Teilleul, Normandy

St Lawrence – Barneville-Carteret, Normandy

St Martin – Montmartin-sur-Mer, Normandy

St Mary – Longues-sur-Mer, Normandy

St Peter – St Hilaire du Harcouët, Normandy

Timeline

Early humans hunt mammoths off La Cotte.

Raiders kill Saint Helier.

Charter confirming independence of the island signed.

Sir Walter Raleigh appointed Governor.

Dolmens and standing stones erected around the island.

'Jersoi' first mentioned in a charter of Duke Richard II.

Papal Bull confirms the neutrality of Jersey in times of war.

250,000 BC 35,000 BC 555 1025 1341 1483 1600

65,000 BC 300 933 1204 1460 1547 1648

As sea levels rise, Jersey becomes an island.

Channel Islands become part of Normandy.

Pierre de Brézé invades and holds Jersey for six years.

Charles II proclaimed King in the Market Place

Channel Islands named in the itinerary of Antoninus.

King John loses Normandy and Jersey becomes the front line in the wars between the England and France.

Reformation, and the destruction of roadside crosses.

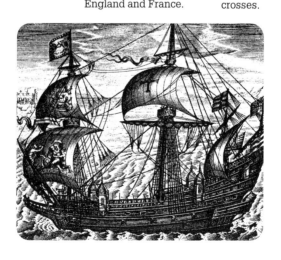

More French Huguenots arrive following the revocation of the Edict of Nantes.

Financial crash as the Jersey Banking Co. collapses.

Five year German occupation begins.

South-East coast of Jersey becomes a protected Ramsar site.

Thousands of refugees fleeing the French Revolution arrive.

First steamship service to England.

6,292 islanders serve in the First World War, of whom 862 were killed.

The Beatles play at Springfield Stadium.

1685 1789 1854 1886 1914 1940 1963 2000

1781 1824 1870 1908 1937 1944 1981 2008

Battle of Jersey.

First steamship service to England.

The first cinema in Jersey opens.

Arrival of SS *Vega* saves starving islanders.

Bergerac first shown on BBC One.

Opening of the St Helier to St Aubin Railway.

Jersey Airport opens.

Historic child abuse investigation begins at Haut de la Garenne, to international attention.

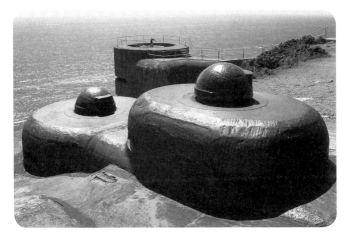

Seasons

Heatwaves
The highest temperature recorded was 36°C on 9 August 2003, with the highest overnight temperature being 22.3°C (on 5 August 2003).

Freezes
The lowest temperature on record was -10.3°C, which was taken on 5 January 1854. The lowest daytime temperature, recorded as -6.1°C over 100 years later, occurred on 12 January 1987.

Rainfall and Drought
The wettest day ever recorded in Jersey, with 95.7mm of rain, was on 24 August 1931. The year that the most rainfall was recorded was in 1960, with 1,107.06mm (compared to the driest year 1921 with 426mm of rain). The longest period without any rain was the thirty-nine days between 21 July and 28 August 1976.

Sunshine
Jersey is the sunniest place in the British Isles, with around 2,000 hours of sunshine per year. The year 1956 had the most, at 2,290.7 hours. In contrast, 1981 had only 1,585.7 hours.

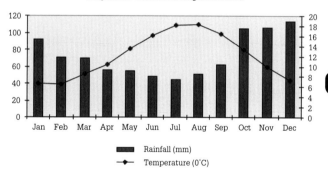

Temperature & Rainfall Averages 1981-2010

Rainfall (mm)
Temperature (0˚C)

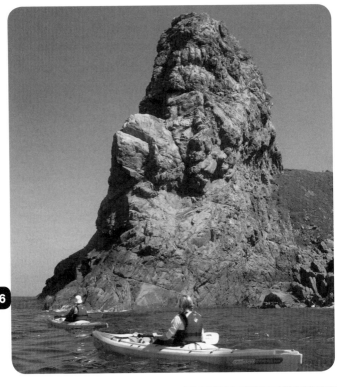

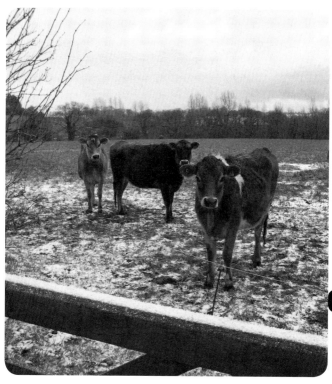

Jèrriais

Jèrriais is the form of the Norman language developed over the centuries in our isolated island community. Its use has been in decline over the past couple of centuries as English has become the language of education, commerce and administration. When questioned in 2001, only 113 residents said it was their first language. Some phrases include:

Bouônjour – Hello

Coumme est qu'ous êtes? – How are you?

Tch'est qu'est vot' nom? – What is your name?

Man nom est – My name is

Bônsouair – Good evening

À bétôt – Goodbye

Below is the national anthem in Jèrriais, with – as is traditional in the Channel Islands – the British monarch being referred to as 'our Duke' (or Duchess, in this case).

Dgieu sauve not' Duchêsse,
Longue vie à not' Duchêsse,
Dgieu sauve la Reine!
Rends-la victorieuse,
Jouaiyeuse et glorieuse;
Qu'ou règne sus nous heutheuse –
Dgieu sauve la Reine!

Tes dons les pus précieux
Sus yi verse des cieux,
Dgieu sauve la Reine!
Qu'ou défende nouos louais
Et d'un tchoeu et d'eune vouaix
Jé chant'tons à janmais –
Dgieu sauve la Reine!

How Many...

People visit Durrell every year?
150,000

Tourists visit Jersey?
650,000

Tonnes of rubbish are created in Jersey per year?
Around 100,000

Tonnes of waste are recycled in Jersey every year?
Over 30,000

Passengers arrive at Jersey Airport every year?
Over 700,000

Books are borrowed every year from Jersey Library?
450,000

'Visite du branchages' are made each year?
Two, in July and September, when parish officials make sure
that the roads have no overhanging tree branches.

**People take part in the 48.1 mile Itex walk around
the island?**
1,100, of which about 60 per cent finish. On the way, they
consume over 13,000 bottles of water.

Jersey Demographics

How big?
45 square miles (116 square km)

How many people?
According to the 2011 census, there are 97,857 residents, of which 48,296 are male and 49,561 are female; 64,353 are of working age.

Jersey is hence the fourteenth most densely populated state in the world.

Parish	Population	Per cent of population	Density per square km
Grouville	4,866	5	594
St Brelade	10,568	11	803
St Clement	9,221	9	2,141
St Helier	33,522	34	3,541
St John	2,911	3	320
St Lawrence	4,418	6	552
St Martin	3,768	4	368
St Mary	1,752	2	267
St Ouen	4,097	4	270
St Peter	5,003	5	425
St Saviour	13,580	14	1,471
Trinity	3,156	3	253

Ethnicity
Jersey is overwhelmingly white, with just 1.3 per cent identifying themselves as Asian and 0.4 per cent as black, whilst just 0.7 per cent responded that they were of mixed ethnicity.

Place of Birth

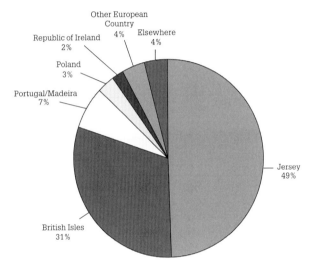

Other European Country 4%

Elsewhere 4%

Republic of Ireland 2%

Poland 3%

Portugal/Madeira 7%

Jersey 49%

British Isles 31%

Parish Statistics

The traditional unit of area measurement in Jersey is the vergée. One Jersey vergée is roughly equivalent to 1.8 square metres, or 0.44 acres.

Area	Square Km	Vergées	Per cent of island
St Ouen	15	8,447	13
St Brelade	12	7,318	11
Trinity	12	6,942	10
St Peter	12	6,539	10
St Martin	10	6,688	9
St Lawrence	10	5,454	8
St Helier	9	5,263	8
St Saviour	9	5,133	8
St John	9	5,060	8
Grouville	8	4,554	7
St Mary	7	3,645	5
St Clement	4	2,393	4

Eponymous Jerseys

Several things are called 'Jersey':

Jersey Cows
The world famous Jersey cow is well known for its rich milk and is popular with farmers because of its lower maintenance costs and genial disposition.

Jersey Royal Potato
First grown around 1880, by the late 1890s around 60,000 tonnes were being exported annually. Exports still make up almost half of the island's income from agricultural products, and have a market value of £35 million. They possess a Protected Designation of Origin Status so that only those from Jersey can be called 'Jersey Royals'.

Woollen Jerseys
These thick knitted jumpers have been made on the island for centuries to keep maritime workers warm. However, the real profits were made in the early modern period with the production of woollen stockings, which were exported in great quantities to England and France.

HMS *Jersey*
Eight ships of the Royal Navy have been given the name HMS *Jersey*. The last incarnation of HMS *Jersey* was sold to the Bangladeshi navy in 1994 and is now a training ship *Shaheed Ruhul Amin*.

Jersey Cabbage
Nicknamed the 'Long Jack', Jersey cabbages can reach heights of 20ft. The stalk has traditionally been used to make distinctive walking sticks. The leaves are used as cattle fodder, but can also be used to wrap a cabbage loaf while baking.

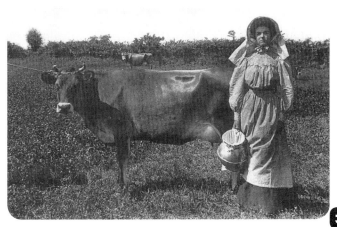

Literary quotations

'I say and will say that I am Wace from the Isle of Jersey, which is in the sea towards the west and belongs to the territory of Normandy.'

Wace, Roman de Rou, *c.*1170

'Faire Iersey first of these here scattred in the Deepe, Peculliarlie that boast'st thy double-horned sheepe.'

Michael Drayton, *Poly-Olbion*, 1612

'Mount Orgueil Castle is a lofty pile,
within the Easterne parts of Jersy Isle,
Seated upon a Rocke, full large & high,
Close by the sea-shore, next to Normandie;
Within a Peere, safe both from Wind and Tide.
Three parts thereof the flowing Seas surround,
The fourth is firme rockie ground.'

William Prynne, *Mont Orgueil Castle*, written while he was being held prisoner there, 1637-40

'Jersey sleeps in the tides, rumbling into infinity,
and in her smallness she has the two greatnesses;
An island, she has the ocean; a rock, she is the mountain.
To the south of Normandy, to the north of Brittany.
She is France for us, and in her bed of flowers
She is both smiles and sometimes tears.'

Victor Hugo, *Jersey*, 1881

'I wasn't all that struck on Beautiful Jersey, as they liked to call it; and I have never wanted to go again.'

G.B. Edwards, *The Book of Ebenezer Le Page*, 1981

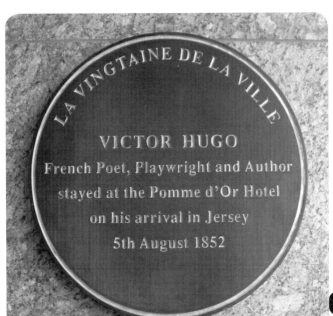

LA VINGTAINE DE LA VILLE

VICTOR HUGO
French Poet, Playwright and Author
stayed at the Pomme d'Or Hotel
on his arrival in Jersey
5th August 1852

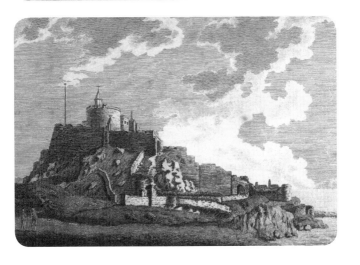

Quotations

'This Island is noe lesse annoyed by several sorts
of vermine, creeping and crawling things, than
damnifyed by the wind and ye water. It is scarce
credible what quantity we have of Toads, snakes,
slowe wormes, rats and mice.'

Jean Poingdestre, seventeenth century

'My little commonwealth.'

Sir Walter Raleigh, 1600

'Jersey has changed a great deal since we were there
together. A vast amount of building, elegant villas, big
hotels – high, almost English prices in them, everything
also much more expensive in the market … The French
language rapidly disappearing, even the country
children now speak almost nothing but English without
any French accent. The increasing availability of money
among certain rising individuals – one can hardly call
them strata – of England's small middle class and the
resulting extent of luxury and of refined so-called good
society was easy to observe in Jersey just because
Jersey is still regarded as inexpensive and hence
unfashionable little island. The respectability standards
of Jersey's visitors seem to decline each year.'

Letter from Karl Marx to Friedrich Engels, September 1874,

'If you want a quiet life, never take a Jersey wife!
Or husband!'

A Guernsey proverb

'Here the artist will find abundant material for his
pencil, the naturalist of every description will fill his
notebook and specimen-box, and the invalid will
enjoy a climate more equable than any in Europe…
The climate of the island is favourable to the health
of old people and children, and is no doubt capable of
checking the progress of most chronic diseases, and of
pulmonary consumption in its early stages.'

Black's Guide to the Channel Islands, 1887

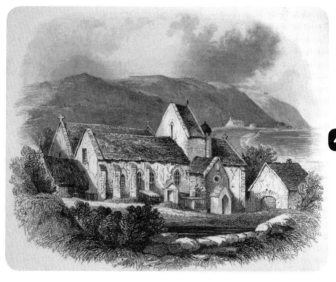

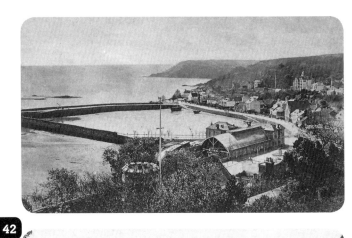

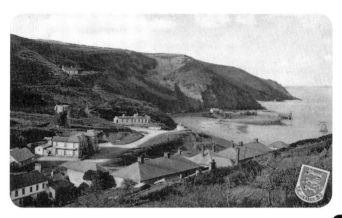

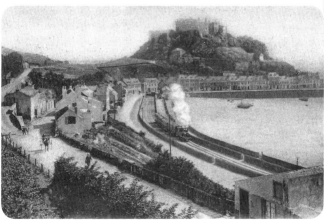

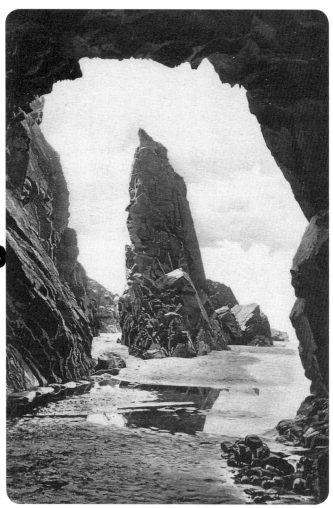

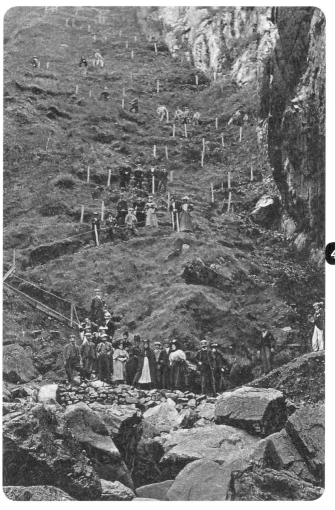

Making the Headlines

Bees on the Loose

'A curious circumstance happened in Colomberie Street on Thursday morning, several of the shops being overrun with bees. They had, it seems, escaped from a hive in La Chasse, much to the sorrow of the owner and the annoyance of the shop-keepers and other residents in the neighbourhood.'

Jersey Times, 13 August 1870

Disfiguring a Monument

'Some time during last night the statue representing George II in the Royal Square was tarred and feathered, the head this morning presenting the ludicrous appearance of wearing a periwig. It is not to be expected that the brainless scamps, who can wrench off knockers and play other tricks at night, will respect public property; the next thing we shall expect to hear is that they have turned the Town Church into a locale for their midnight revelries… On the sun shining the tar melted and ran down the royal nose and face, completely disfiguring the statue. Much indignation is expressed by the inhabitants.'

Jersey Express, 19 September 1876

Mafeking Day anti-French Demonstrations During the Boer War

'A crowd made its way toward Hilgrove lane, marching up and down singing *God Save the Queen*, and occasionally battering the doors and shutters with large sticks and other weapons. This went on for some time and probably nothing more serious would have happened had not Mme Cousinard, a French butcher, very indiscreetly opened one of the upper windows of her house and emptied the contents of a pail of dirty water on the head of the persons standing below.'

Jersey Express, 24 May 1900

Letters to the Press

Forty-two Gun Salute

'Sir – I have for some time got over my former ugly
habit of continually asking questions, but patriotic duty
impels me to enquire why the usual royal salute of 21
guns was not fired last Saturday, June 20th, in honour
of Her Majesty's Accession. Also are we next Sunday,
being Coronation Day, to be similarly treated? I would
modestly suggest that a double Royal salute of 42 guns
to be fired at noon from Elizabeth Castle as an "amende
honourable" for the omission of Saturday last.'

Yours, Socrates

Jersey Times, 25 June 1896

Criticism of the Militia

'Sir – I remember the outcry raised by the thin-skinned
Jersiais and the criticism heaped upon our late
beloved Lieut-Governor for a sensible remark made
by him in the States 'that the militia was not only
useless but positively dangerous for its utter want of
discipline.' Sir, how justified have those words been
by the disgraceful occurrence at the ceremony of
laying the foundation stone of the Jersey waterworks
on Wednesday? ... Charged with bayonets fixed in an
offensive crowd of men, women and children in aid of a
stupid Centenier, who would have much better cleared
the tent had he used a little tact and civility instead of
bluster. Several persons were pricked by the bayonets,
one or two rather severely.'

Yours, A Linesman

British Press, 4 October 1869

Riots and Protests

February 1656 – Captain Sansum arrived in the Channel Island to impress (i.e. force) local men into the Navy. He did not have much luck in Guernsey, and on arrival in Jersey he explained: 'I found the Governor very willing to assist me, but the inhabitants were not, and forced my men to take to a house for security; had not the Governor assisted them with a party of horse, who had to fire upon the people, killing one and wounding several others, they would have been destroyed. I only succeed in pressing 50 men in both islands.'

1847 – The Bread Riots began with workers complaining about the price of bread compared to their low wages. The men then attacked the town mills: 'The door of the upper story at the back of the house resisted their attempts for a short time, until a long spar, used as a battering-ram, forced it open, and then began on of those shameful scenes witnessed only on similar occasions among savages… One of the ringleaders was observed cramming his mouth with wheat, crying out that he had not eaten for two days.'

1864 – Riot at the Prince of Wales Assembly Rooms during a lecture by Mr T.G. Owns on 'Bible truths and Romish Errors.' An irate group of the island's Catholic community, 'many of them armed with bludgeons, collected at the doors of the lecture hall and commenced yelling and hooting. They were aided and urged on by between 20 and 30 women. After creating immense uproar outside, they smashed the windows of the hall by throwing stones through them while some of the women yelled "fire, fire!"'

Dolmens

The landscape of Neolithic Jersey was littered with ritual monuments, dolmens and standing stones, many of which can still be seen today. Among the most impressive are:

La Houge Bie

A 12-metre high earth mound that covers a 20-metre long passage chamber was in use and then sealed around 3500 BC. In 1924 the Société Jersiaise excavated the site and discovered the entrance to the tomb. The remains were found of at least eight people with grave goods that included flint tools, pottery, limpet shells, beads and bones from early-domesticated ox, sheep and pigs.

La Pouquelay de Faldouet

Dating from 4000-3250 BC, the most impressive feature of this superb dolmen is the 24-tonne capstone which covers the end chamber. Finds here include stone tools, pottery and the bones of at least three individuals.

Le Mont de la Ville

A passage grave nicknamed 'Little Master Stonehenge' that was uncovered in 1785 on the Town Hill where Fort Regent now stands. Unfortunately for us, the good men of St Helier voted to present the monument to the then Governor, Seymour Conway, who promptly shipped it to Henley-on-Thames, where it was reconstructed and stands to this day.

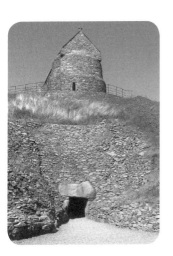

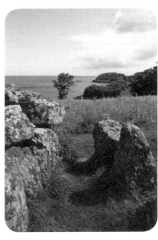

Castles

Mont Orgueil

This closest point of mainland Jersey to France has been occupied since the Iron Age. Work on the fortification had begun by 1209 and numerous additions were made over the following centuries. However, advances in gunpowder technology made the castle obsolete by the end of the sixteenth century and it was replaced by Elizabeth Castle as the island's premier fortification. However, the castle was to have a second life as a prison for both common criminals from the island and political prisoners from England. During the Revolutionary and Napoleonic wars, a Jerseyman, Philippe d'Auvergne, ran a spy network known as 'La Correspondance' from the castle.

Grosnez

This was constructed in the fourteenth century as a refuge from invaders. Although now a ruin, the castle's gateway still makes an imposing sight against the backdrop of the rugged north-west coast.

Chastel-Sedement

A large earthwork, with moat, in Trinity, covering an area of 10 acres. It provided refuge to people and livestock during the raid of corsair Don Pero Niño in 1406.

Elizabeth Castle

Elizabeth Castle was Sir Walter Raleigh's official residence on the island while he was Governor in 1600-1603. He named it Fort Isabella Bellissima, 'the most beautiful Elizabeth'. Accessible by foot only at low tide, it appears impregnable. However, the castle was finally captured in 1651 when mortar fire struck and destroyed the ancient abbey church in the castle, which was being used to store ammunition at the time it was hit. The resulting explosion devastated the surrounding buildings and forced the castle's surrender.

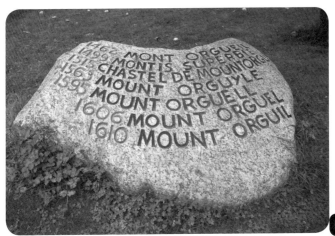

1467 MONT ORGUEIL
1499 MONTIS SUPERBI
1515 CHASTEL DE MOUNTORGA
1563 MOUNT ORGUYLE
1595 MOUNT ORGUELL
1606 MOUNT ORGUEL
1610 MOUNT ORGUIL

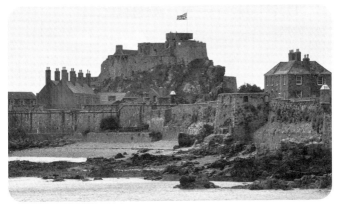

Museums

Jersey Museum and Art Gallery
Set in a restored Victorian merchant's house, the museum tells the island's story from prehistoric times to the modern day. The displays are mixed but there are some worth seeking out, such as the marvellous Bronze Age torque made from 750 grams of Irish gold.

Hampton Country Life Museum
A fine example of an old Jersey farmhouse. The best time to visit is during La Faîs'sie d'Cider festival in October, when traditional cider making takes place.

Maritime Museum
Built to represent Jersey's long relationship with the sea. Shipbuilding used to be a major industry on the island, as the modest cost of local labour and the lack of taxes increased the orders from English ship owners. Between 1855 and 1869, over 300 vessels were built, and the figurehead of one of them, the *Prospero*, can be seen at the museum.

La Hougue Bie Geology and Archaeology Museum
The most impressive items in the collection are the woolly mammoth, woolly rhinoceros, cave bear and reindeer remains that were found at La Cotte. The geology museum explains Jersey's volcanic beginnings and the remarkable variety of rock types that make up the island.

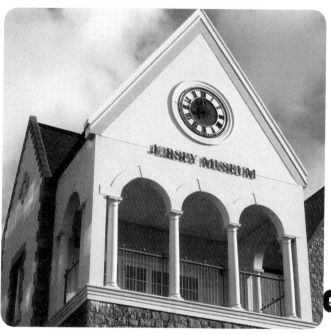

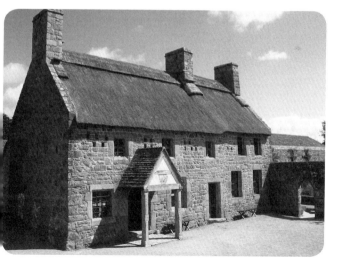

Battle of Jersey Commanders

Phillippe de Rullecourt (1744-1781) – A mercenary from Flanders who became a general of the Kingdom of France. In 1779 he was second in command to the Prince of Nassau's failed invasion attempt of Jersey. He was not put off and two years later he led 2,000 badly equipped troops in an invasion that met with disaster in the Battle of Jersey. De Rullecourt was mortally wounded in the battle and died the following day in what is now the Peirson Pub.

Major Francis Peirson (1757-1781) – Peirson arrived on the island as an officer of the 95th Regiment of Foot. When French forces captured the commander of the garrison on 6 January 1781, Peirson took command of the British forces and led them into St Helier where they met the enemy at what is now the Royal Square. The battle was over in quarter of an hour but the young major, leading from the front, was shot in the heart and died. The scene is immortalised in John Singleton Copley's *The Death of Major Peirson*, which you can see on a Jersey £10 note.

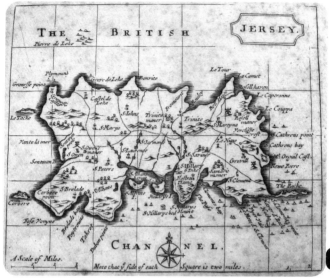

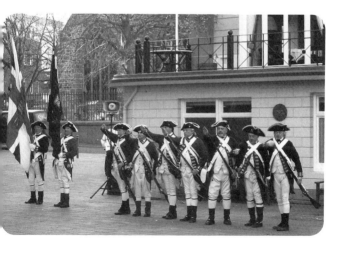

Towers

The round towers were built between 1779 and 1837 to protect the island from French invasion during the Revolutionary and Napoleonic wars.

A total of thirty-one were built, of which twenty-four remain (some of which have become private homes).

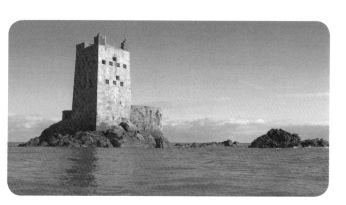

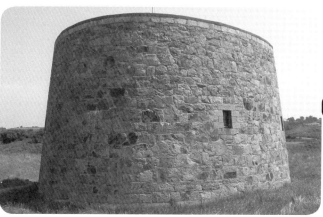

61

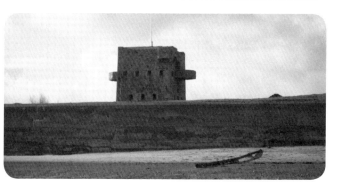

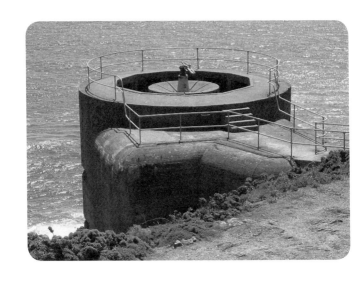

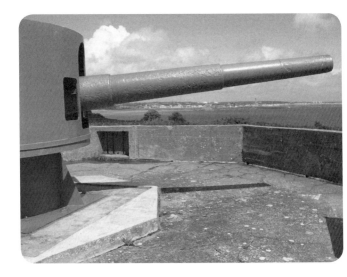

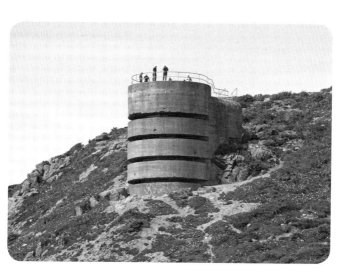

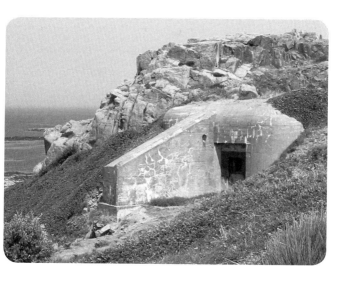

Jersey's Other Islands

As well as the island itself, the Bailiwick of Jersey also comprises of a number of offshore islands and reefs, all of which are Ramsar sites (recognising their ecological and scientific value).

Les Écréhous

Six miles north-east of Jersey and administratively part of the Parish of St Martin, all but three of these islands are submerged at high tide. They were a hotbed for smuggling in the seventeenth century, when the Lieutenant-Governor himself participated in the illicit trade. On election days, candidates sometimes dumped people here who were going to vote for their opponents.

Les Minquiers

Situated 9 miles south of Jersey and administratively part of Grouville, Les Minquiers have been the source of much dispute between Jersey and France. Only the islet of Maîtr'Ile has houses, none of which are permanently occupied. Les Minquiers boast a flagpole, a helipad and the southernmost toilet in the British Isles.

Pierres de Lecq (Paternosters)

A reef north of St Mary, one with the widest tidal range in the world. At high tide only three of the rocks remain visible: L'Êtaîthe (the eastern one), La Grôsse (the big one) and La Vouêtaîthe (the western one).

Les Dirouilles

A range of rocks to the north-east of Jersey and part of the Les Écréhous Ramsar site.

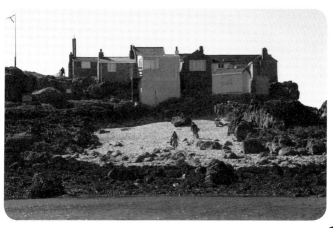

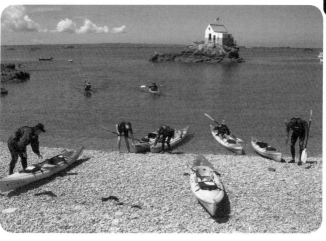

Beaches

Anne Port
In the north-west of the island, a pebbly beach but safe for bathing.

Beauport
A hidden gem that can be reached only by foot and accessed by a path from the car park at the top of the cliffs; seldom gets crowded. It is surrounded by huge rock formations sculpted into fantastic shapes by the elements.

Bouley Bay
The bay is the only deep-water anchorage and the home for a scuba-diving school. It is defended by the magnificent Fort Leicester, which was named after one of Queen Elizabeth I's favourites. The bay was the site for a French invasion in 1549; they were defeated and driven off by the militia at Jardin d'Olivet in Trinity, but Helier De la Rocque, the Lieutenant-Bailiff, was killed.

Green Island
A sandy beach dominated by the grass-topped outcrop of rock. It was originally a peninsula, but in around 1600 sea erosion finally created the island. It is thought to be one of the original centres of Neolithic settlement, perhaps as early as 4000 BC.

Havre des Pas
The main feature of this beach is a sea-water swimming pool that is filled and drained repeatedly by the tide.

Le Hocq
Meaning 'the headland' in Jèrriais, Le Hocq is small sandy beach next to a round tower. Offers good views of the granite outcrop of Rocqueberg, where witches are said to have gathered on a Friday night.

Plemont (Greve au Lancon)
A fantastic beach, and very out the way. Take a torch so you can explore some of Jersey's most impressive sea caves.

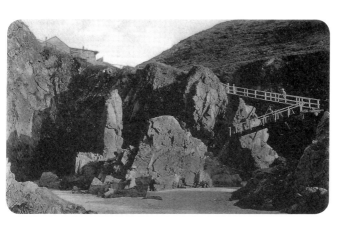

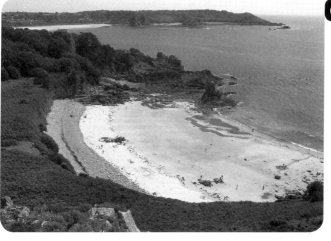

Royal Bay of Grouville

Overlooked by the magnificent Mount Orgueil Castle, the bay is wide, sandy and safe for bathing. The best facilities are concentrated at the northern end of the beach, near the picturesque harbour and Gorey Village.

St Aubin's Bay

Elizabeth Castle and St Aubin's Fort lie on islets in the bay. The beach used to be the island's airport until 1937.

St Ouen's Bay

The premier destination in Jersey for surfing and other water-sports, the bay is often battered by a heavy Atlantic swell. In 1651, the beach was the site for an invasion of Jersey by English Commonwealth troops. They defeated the St Ouen's militia in battle on the beach.

Archirondel

The most distinctive feature of this beach is the red-and-white round tower. It sits on top of the remains of an incomplete breakwater that had been planned to form, with the competed St Catherine's breakwater, a large naval base. After spending an eye-watering £234,235 16*s* 0*d* at 1870s prices, work was abandoned following improved relations with France and problems with the harbour silting up.

Bonne Nuit

A picturesque harbour with working fishing boats moored inside the shelter of the pier.

Greve de Lecq

Home to Jersey's most ferocious gulls – they will steal sandwiches and ice-creams from your hand.

Ouaisne

Next to the bay is the world-class archaeological site of La Cotte, which can be seen cut into the cliffs at the eastern end of the beach. 250,000 years ago Jersey was joined to France, and early hunters used this site for over 150,000 years to drive woolly mammoth and other megafauna to their deaths on the rocks below.

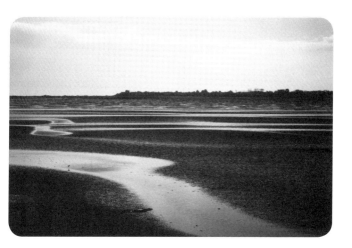

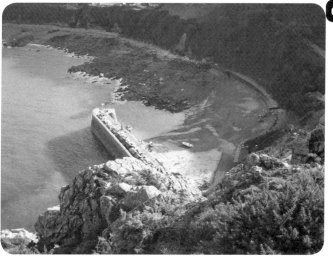

Parks

Coronation Park (Millbrook Park)
An excellent park with a playground for young children. Nearby is St Matthew's (the 'glass church'), with exquisite glass and crystal work by René Lalique.

Howard Davis Park
Features the Jersey War Graves cemetery, plus a walled rose garden and a pond. The gardens are beautifully maintained and within walking distance of the town centre. During the summer, outdoor films and concerts are held in the auditorium.

Les Jardins de la Mer
Situated along the waterfront, this site has fountains and benches which give you a good view of Elizabeth Castle.

Sir Winston Churchill Memorial Park
Boasts a large collection of beautiful exotic plants and established trees, as well as a waterfall.

Millennium Town Park
Eleven years late and at a cost of £10 million, Jersey's newest park opened in October 2011. A pleasant green space in an otherwise built up area, the park boasts a playground, ball courts and water features.

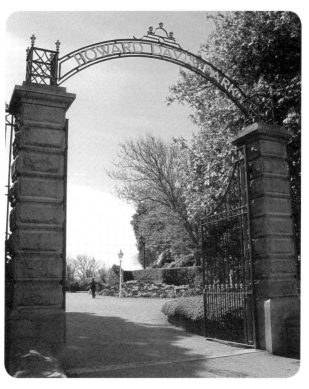

Wild Places

The north coast

Stretching from St Catherine's Breakwater to Grosnez Castle, Jersey's north coast has some of the most spectacular scenery in Europe. The cliff paths can be challenging but there are several good cafés and pubs that make ideal resting places.

Les Blances Banques

Jersey's last remaining sand dune system at the southern end of the Five Mile Road is home to more than 400 plant species. With an area of 100 hectares, it is a site of huge ecological importance and is home to many species of animals, both year round and migrant.

Portelet Common

Covering 31 hectares, the common lies at a height of 54-60 metres above sea level; the common is home to some 125 species of plants, several of which are endangered in Britain.

Les Landes

Les Landes covers an area of 160 hectares and is sounded by 3km of rugged granite cliffs. The sublime cliffs and ruins of Grosnez Castle make this area a favourite for photographers.

Les Creux Millennium Park

Situated above Beauport Bay, these 45 hectares of former open farmland have been turned into a country park. The woodland and heathland support a large number of insect and plant species.

St Catherine's (Rozel) Woods

Covering 18 hectares, St Catherine's is one of the largest and oldest areas of woodlands on the island. During the occupation some 200,000 trees in Jersey were felled as other sources of fuel ran out.

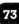

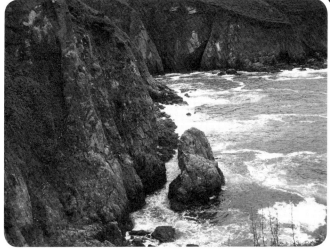

Reptiles and Amphibians

Agile frog
The poster child for local conservation, Jersey is the only place in Britain where this species of European Brown Frog can be found. As with many species of amphibians, their population has been in decline for many years due to a loss of habitat and pollution.

Jersey toads/crapaud
Toads are distinctive from frogs as they have a drier skin and walk rather than hop. Jersey men and women are known as crapauds by Guernsey men because of the abundance of these animals here compared to their own island.

Grass snake
The only species of snake living wild in Jersey, grass snakes are about 80cm long and are a dull green/brown colour, with a cream belly and distinctive black markings.

Green lizard
Jersey is the only place in Britain where green lizards occur naturally. During the summer months they can often be seen in warm sandy areas along the south and west coasts. In winter they hibernate in burrows.

Wall lizards
A common sight scuttering along the rocks of the north coast, and at Mont Orgueil Castle.

Slow worms
A legless lizard that likes to burrow, they are said to be the longest-lived lizard, reaching ages of about thirty in the wild. The females have a distinctive stripe along their spine, while the males have blue spots.

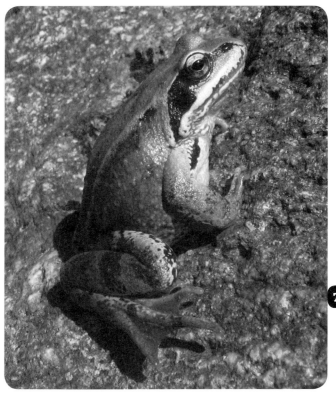

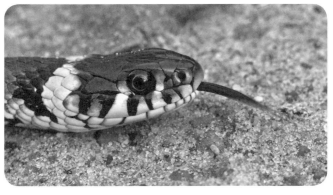

Mammals

Red squirrel

In decline in much of Britain, but Jersey has a healthy population due to lack of competition with grey squirrels. An invasive species, they were introduced in 1885 and can now be found over much of the wooded areas of the island. They have found their way into the hearts of many islanders, and plenty of gardens boast specially designed squirrel feeding boxes. Research has suggested that this high energy food has been boosting their population by extending their breeding season. So that groups can mix and interbreed, many of the island's roads have rope bridges so the squirrels can cross safely and 20,000 hedgerow trees have been planted to provide safe cover.

Pipistrelle bats

The most common bat on the island, and weighing a mere five grams, they consume up to 3,000 insects in a single night, catching and eating them in flight. Jersey's bats are protected by law and make up to 40 per cent of all local mammal species.

Bottle-nosed dolphins

The most common species of dolphin to be seen off Jersey's waters. They are attracted to boats and will ride the bow wave of all vessels from small fishing boats to car ferries. Approximately 100 live in the shallow waters around the island.

Manx sheep

Introduced by the National Trust for Jersey in 2008 as part of a conservation-grazing programme to restore Jersey's coastal grassland and heath, Manx sheep are the closest surviving breed to the now extinct Jersey sheep.

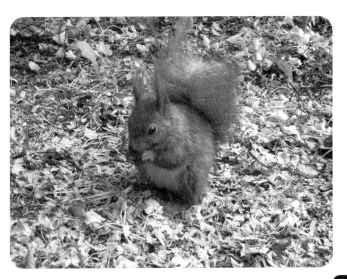

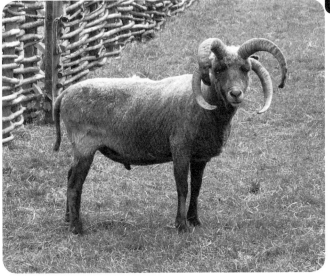

Birds

Jersey is rich in bird life and is home to a diverse number of species. Some of my favourites are:

Marsh harrier

These magnificent birds bred for the first time in Jersey for many years in 2002 and are now a common sight in the rural parishes. The adult males are dark brown with a pale cream-coloured head and ash-grey tail. Females are larger and have a more pronounced creamy-coloured head and throat with pale creamy patches on the shoulders.

Skylark

In decline around Europe. However, a conservation campaign to protect their nesting ground along the Five Mile Road means that you can hear their wonderful song whilst walking along the sand dunes.

Oystercatcher

A very noisy bird with a distinctive orange bill. They are present throughout the year but the numbers increase substantially in the autumn when many hundreds of British and Scandinavian birds arrive to spend the winter here.

Little egret

Twenty years ago they lived much further south in Europe but are now a fairly common sight among the rocks at low tide.

Kestrel

The most common bird of prey in Jersey, they can often be seen hovering or perching by the side of a road.

Greater spotted woodpecker

First bred in Jersey in 1952 at Rosel Manor woods, this type of woodpecker has since spread across much of the wooded areas of the island and can often be found on garden birdfeeders, where they will hog the peanuts.

Dartford warbler

Population levels have suffered in the past but are now improving thanks to the preservation of Jersey's heathland. You can often hear them when they perch atop a gorse stem to sing.

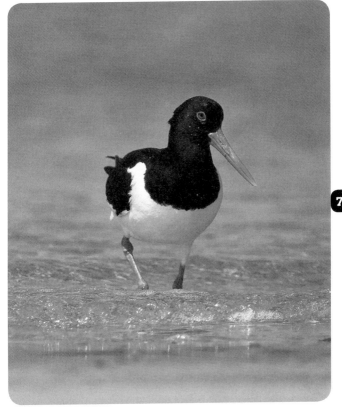

Economy

Traditionally based on agriculture and fishing, Jersey's economy changed dramatically in 1962 when the States repealed a law of 1771 that restricted bank interest to 5 per cent. Within months, a number of merchant banks had moved to St Helier, attracted by a community that was financially and politically stable.

In 2010, 1,327 funds with a collective value of £178.9 billion were being administered from Jersey. However, Jersey's status as a secretive tax haven has many critics, with one commentator calling it the 'North Korea of the English Channel'.

Economy

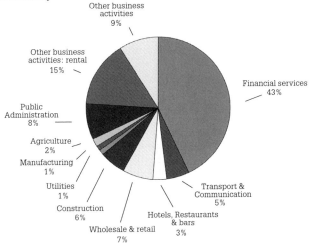

Other business activities
9%

Other business activities: rental
15%

Public Administration
8%

Agriculture
2%

Manufacturing
1%

Utilities
1%

Construction
6%

Wholesale & retail
7%

Hotels, Restaurants & bars
3%

Transport & Communication
5%

Financial services
43%

Occupation

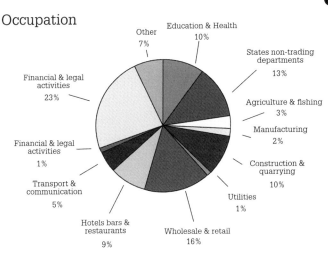

Other
7%

Education & Health
10%

States non-trading departments
13%

Agriculture & fishing
3%

Manufacturing
2%

Construction & quarrying
10%

Utilities
1%

Wholesale & retail
16%

Hotels bars & restaurants
9%

Transport & communication
5%

Financial & legal activities
1%

Financial & legal activities
23%

Crimes and Court Cases

Drogo de Barentin – This medieval Seigneur of Rozel terrorised his tenants. He was brought before a court of assize in 1299 following a long list of complaints including abduction, gang rape, extortion, robbery and murder. However, due to his position he was only fined 300 *livres tournois*, and even returned to the island in an even higher appointment, as Warden of the Isles.

Mont Orgueil Castle – Prior to the building of a prison at Charing Cross, inmates had to be escorted from Mont Orgueil Castle to appear before the court. While waiting for their case to be heard, prisoners were held in a cage in the market place. Nearby were the public stocks where offenders could be pelted with rotten fruit and vegetables or stones. In 1619 one woman was sentenced to the stocks for spending a night on the town 'dressed as a man and wearing breeches'. The stocks were still being used in 1835 for cases of forgery.

1807 – William Hales, an English soldier stationed in Jersey during the Napoleonic Wars, bored and in need of cash, began committing burglaries to pay his debts. He killed a man following a struggle during one break-in, and was sentenced to death by hanging. However, the rope slipped, and Hales fell to the ground. Such a thing had never happened before, so the guards took Hales back to the prison. The following Monday, after receiving a petition from the inhabitants of Jersey, the Royal Court decided to give him the King's pardon.

1846 – Centenier Georges Le Cornier went to an address in Patriotic Street to arrest the owner and his wife for allegedly running a brothel. When the Le Cornier tried to arrest the wife, she stabbed him in the stomach with a carving knife; he died the following day. He is the only officer to be killed in the line of duty in the long history of the honorary police.

Today Jersey is one of the safest places in Britain. Police recorded 4,554 crimes in 2010. Roughly a third, or 34 per cent, of the reported crimes resulted in offenders being charged or reported to Parish Hall Enquiry Court.

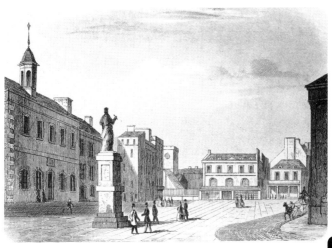

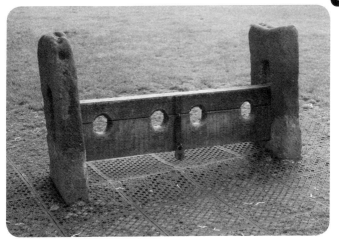

Privateers and Smugglers

During the English Civil War, when Sir George Carteret held Jersey for the King, the island became a notorious base for privateers who preyed on the ships of the English Commonwealth. The ship owners of St Aubin became rich when their vessels came back to port: the goods they had stolen were auctioned off at the quayside, and the prize money was divided up. On 8 May 1649, the *Hart* returned to St Aubin after capturing a vessel of 96 tonnes. Jean Chevalier describes how the cellars of the village were filled to capacity with sixteen barrels of Malaga wine, three barrels of sweet oil, two barrels of heavy oil, bales of cloth, timber and many other goods. Jersey's privateers continued their activities after the war and into the following century, and by 1711 over 150 ships had been taken.

Value of goods taken by Jersey Privateers during:

The Seven Years War (1756-1763): £60,000 (£4 million today)
1778: £343,500 (£17.2 million)
1779: £270,000 (£13.5 million)
1782: £156,000 (£10.5 million)

As in all maritime communities, islanders have often turned to smuggling to supplement their income. Jersey has made an excellent staging post in the route between England and France, with many fine beaches and inlets for landing goods on moonlit nights. The major commodities smuggled through the island were wine, tea, brandy and tobacco.

Smuggling continued well into the nineteenth century:

'Certain information was lodged at the custom house on Saturday night, and in consequence of it Messrs W. Mackay and W.F. Baker afterwards proceeded to St Catherines Bay. At Midnight they found seven men in the act of shipping goods on board two French luggers which lay in the bay. They arrested five of the men, and discovered that what they were shipping consisted of 916lbs of tobacco, 315lbs of sugar, and 76lbs of candles.'
The British Press, 30 January 1870

Ghosts

Black Dog of Bouley Bay

La Chien de Boyley was described as a huge, black dog, with eyes the size of saucers, which roamed the paths around the bay dragging its chain behind it. No one was ever reported to have been harmed by the dog, and in all probability the legend was promoted by smugglers who were keen to keep people away from an ideal landing site for illicit goods.

Ghostly Bridal Procession

Many years ago a young couple were walking home at night through what is now Waterworks Valley when they heard the peal of wedding bells. To their great surprise a bridal procession appeared behind them – a coach drawn by six horses. When the couple saw the bride, they leapt back in horror: under her veil there was just a skull. When they told locals about their encounter they were informed that they had seen the ghost of a bride who went to St Lawrence church to be married, but her groom never arrived. She was so sad that she killed herself, and now, once a year, she drives down the valley, trying to find her disloyal fiancé.

Mysterious Kitten

A woman was walking past Carrefour à Cendres in St Peter when she saw a lost kitten under a hedge. Out of pity she decided to take it home, but as she was walking home the kitten grew in size until it became too heavy for her to carry. The now much enlarged cat dug its claws in and would not be put down, so the women retraced her steps to where she had found the animal – and as she was walking it reverted to its previous size.

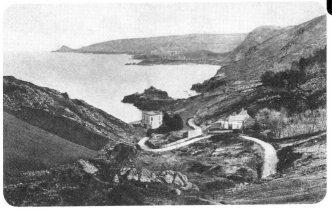

Witchcraft

Allegations of witchcraft were widespread in Jersey during the sixteenth and seventeenth centuries, and at least sixty-six people were accused of being in league with the Devil. They were by no means all old women; in fact, several were still in their teens. Half of those found guilty were sentenced to death, the other half being banished from the island or released with a severe warning. But they were normally spared the final agony of being burnt to death – in the traditional Jersey method, they were strangled first.

On the sides of the chimneys of old farmhouses, you will often see a stone that juts out; these used to prevent seepage of rainwater when the roofs were originally thatched. These are known as 'witches' stones', and local lore has it that they were used by witches as resting places on their flights over the island.

The last person executed for witchcraft in Jersey was Marie Le Dain in 1660.

Mary Tourgis

Mary's mother had been hung for murder, a trauma that must have affected Mary greatly in her childhood. Mary herself was first accused of being a witch in 1608, but was acquitted because of her youth. Ten years later she was in court again, accused of practicing witchcraft and causing the death of a child. She was condemned to death, to be 'hanged and strangled till death ensued, and her body reduced to ashes.'

Symon Vauldin

Symon was a male witch who confessed to communicating with the Devil when he appeared in the form of a cat or a raven. He was also executed by strangling and then burning.

Mary Esnouf

A granddaughter of a former rector of St John, Mary was tried in 1648 after over sixty witnesses accused her of diabolical acts. She was deemed to be a witch after a Devil's mark was found in her mouth and she felt no pain when pricked by a lancet. Mary was sentenced to be hanged, strangled and then burned in the market place. She met her end before a crowd larger than that which would see Charles II crowned there the following year.

Livestock

In 2009, the following animals were kept in Jersey:

Cows and Heifers: 5,090

Pigs: 620

Poultry: 20,560

Sheep: 860

Goats: 20

Equines: 800

Favourite Scenes

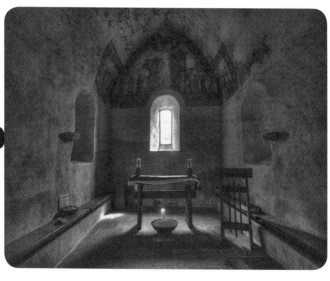

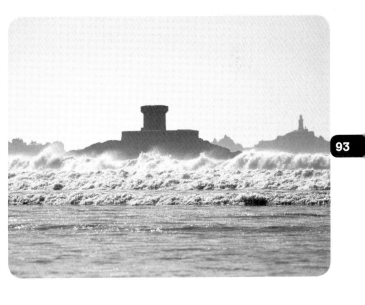

Least Favourite Scenes

Festivals

Liberation Day
A national holiday on 9 May to celebrate liberation in 1945 from the German occupation.

Battle of the Flowers
The parade was first held in 1902 to celebrate the coronation of King Edward VII and Queen Alexandra. It was so popular that the authorities decided to make it an annual event.

International Air Display
The best free air display in Europe takes place in Jersey each September, drawing large crowds along St Aubin's Bay. Organised by the RAF Association, it helps raise funds for various Forces charities.

Jersey Live
Jersey's premier live music festival has been going since 2004, with artists performing to a 10,000 capacity crowd at the Royal Jersey Showground in Trinity.

Jersey Eisteddfod
This cultural competition is held twice annually, with the Festival of Creative Arts being held in March and the Festival of Performing Arts in November. Each festival attracts almost 3,000 entries.

Branchage Film Festival
A cutting-edge festival which showcases dozens of films each year: many are screened in unusual locations such as a surfboard factory, an old barracks and on a boat.

La Fête dé Noué
A Christmas festival that includes a floodlit parade.

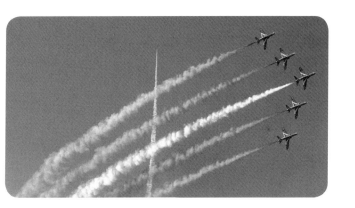

Saint Helier

St Helier was a hermit monk who lived in Jersey during the sixth century on an islet in the Bay of St Aubin, where Elizabeth Castle now stands. He is reputed to have converted many on the island to Christianity.

He was martyred by a band of raiders, who beheaded him in AD 555. Legend has it that he picked up his own head and walked to the shore where the town church now stands. His feast day is July 16 and is marked by a pilgrimage to the hermitage on the islet. Helier is invoked as a healing saint for diseases of the skin and eyes.

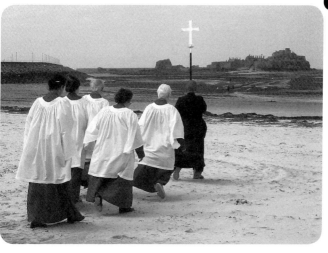

Famous Islanders: A Selection

Wace (*c.*1115-1183)
A Jersey-born poet who wrote two major works of the Anglo-Norman language. His *Roman de Brut* is the first work to mention King Arthur and his knights having a round table.

Jean Chevalier (1589-1675)
A diarist who kept a gossipy record of events in Jersey during the civil war.

George Carteret (1610-1680)
A dictator of Jersey during the civil war and held the island for the Royalists until it fell in 1651. After the Restoration of Charles II, Carteret was awarded for his loyalty with the position of Treasurer of the Navy. He became a good friend of the diarist Samuel Pepys, who called him 'the most passionate man in the world', but deplored his 'perverse ignorance' of affairs of business.

Jean Martel (1684-1753)
Martel emigrated to France in 1715. He founded a trading house in Cognac and began exporting the fine brandy that still bears his name.

Daniel Dumaresq (1713-1805)
An educational consultant for Catherine the Great of Russia and Stanislaw II of Poland.

Philip Carteret (1733-1796)
A British Naval officer and explorer who commanded the *Swallow*, which circumnavigated the world from 1766-1769.

Lillie Langtry (1853-1929)
An actress who had a number of prominent lovers, including the future King Edward VII. Lillie was first woman to use her celebrity to endorse a commercial product, advertising Pears Soap.

Harry Vardon (1870-1937)
Born in Grouville, Vardon became one of the most famous golfers of all time, winning the Open Championship a record six times.

Thomas Davis (1867-1942)
A great benefactor. Davis donated the land and money for Howard Davis Agricultural Research Farm and Howard Davis Park in memory of his son, who was killed during the Battle of the Somme.

Phyllis Pattimore
A Jersey girl who left the island before the German Occupation in 1940. She became a secret agent; part of Churchill's Special Operations Executive, she was parachuted into occupied France to deliver messages from the British High Command to French Resistance fighters.

Medieval Invaders

Eustace the Monk (c.1170-1217)
A former Benedictine monk, Eustace left holy orders for the more profitable employment of being a pirate. Setting up a base in Sark, he became a mercenary for both the English and the French Kings over the years. In 1205 he helped expel French forces from Jersey. Several years later he switched sides and attacked the island on behalf of the French.

David II, King of Scotland (1329-1371)
Ravaged the Channel Islands while he was in exile in France. In 1336 he attacked Jersey, 'inhumanly committing arson, murder and diverse other atrocities.'

Bertrand du Guesclin (c.320-1380)
The 'Black dog of Brittany' and French hero of the Hundred Years War invaded Jersey with a large force in 1373. His men burnt property and killed men and women indiscriminately. They captured Grosnez Castle easily and would have taken Mont Orgueil as well if not for the timely arrival of an English fleet. Du Guesclin finally left the island after receiving a large ransom.

Don Pero Niño (1378-1453)
A Castilian nobleman and pirate who invaded Jersey in 1403, where he defeated islanders in a battle on St Aubin's Bay. He took prisoners and looted much of the island but was unable to take the strongholds. He was finally brought off with a ransom of 10,000 crowns.

Pierre de Brézé (1410-1465)
Seneschal of Normandy and childhood friend of Margaret of Anjou, Queen to King Henry VI. During the Wars of the Roses Margaret encouraged Pierre to invade the Channel Islands to aid the Lancastrian cause. De Bréré captured Mont Orgueil Castle without a fight in 1461 and French forces held the island for seven years. They were finally expelled through a combined force led by Seigneur Philippe de Carteret, commanding the Island Militia, and Sir Richard Harliston, who secretly landed his Yorkist forces at Plémont.

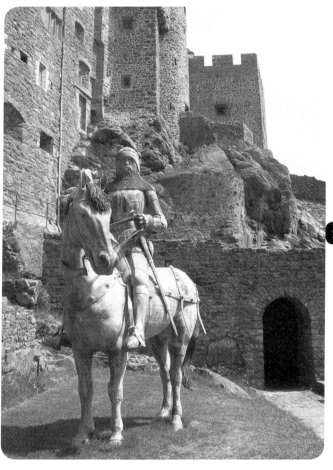

Famous Visitors and Residents

Charles II was exiled in Jersey, 1649-1650.

Sir Walter Raleigh was Governor between 1600 and 1603.

Isambard Kingdom Brunel inspected St Catherine's Breakwater in 1848.

Victor Hugo was exiled in Jersey, 1852-1855.

George Elliot stayed in Gorey village in 1857.

Charlie Chaplin performed at the Opera House in 1912.

Winston Churchill visited in 1913.

Alan Whicker is a journalist and presenter of *Whicker's World* who lives on the island.

Gerald Durrell (1925-1995) founded the world-famous Durrell Wildlife Conservation Trust in Jersey in 1958. He is also the author of many books, including *My Family and Other Animals*.

Dr Who actor **Tom Baker** spent time as a student at a local Jesuit College in the 1950s.

Jack Higgins, the best-selling author of *The Eagle Has Landed* and many other novels, has lived in Jersey since the 1970s. His 1986 novel *Night of the Fox* is set on the island during the German occupation.

Gilbert O'Sullivan is a singer-songwriter who had a number of hits in the 1970s.

John Nettles is a well-known actor who stared in the BBC series *Bergerac*, which ran from 1981 to 1991.

Jambo was a silverback lowland gorilla who lived at Jersey Zoo between 1972 and his death in 1992. He became internationally famous in 1986 after a five-year-old boy fell into the gorilla enclosure and Jambo stood guard over the unconscious child.

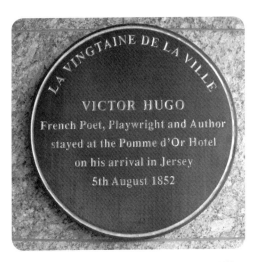

Island Cuisine

Gâches à fouée – Eaten at Easter, these are flat discs of bread eaten with butter.

Des fliottes – Eaten on Good Friday. Small buns cooked in boiling milk and served with milk and sugar.

Ormers – The shellfish are a prized delicacy. Population decline has meant that they can only be gathered on an 'ormering tide' between January and April. Ormers have to be well beaten with a steak hammer or rolling pin before cooking in a casserole for four to five hours.

Cabbage loaf – The dough is wrapped in cabbage leaves before being baked to give it a distinctive flavour.

Wonders – Sweet cakes similar to doughnuts but with no jam and not covered in sugar. Only cooked on an outgoing tide.

Bean crock – There are many different recipes for this dish but most are based on a mixture of dried beans and pork. Early English visitors thought that locals ate nothing else and dubbed them 'Jersey beans'.

Conger eels – Once formed a large part of islanders' diet. Popular dishes included conger soup and eel pie. They were also salted and dried and exported to France.

Cider – Prior to potatoes, cider apples were Jersey's main crops, with an annual production of 7 to 8 million litres in 1801.

Black butter – An apple preserve for spreading on bread. It is traditionally made on an autumn evening known as Séthée D'Nièr Beurre (black butter night).

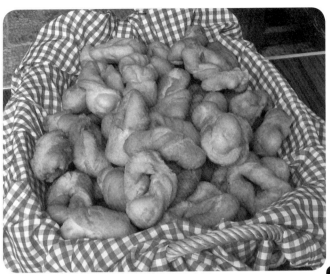

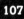

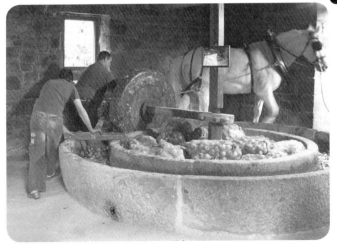

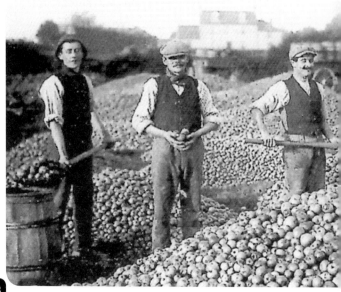

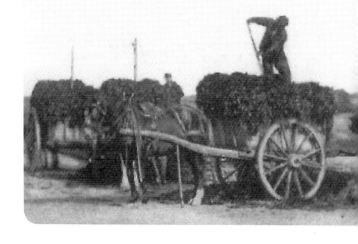

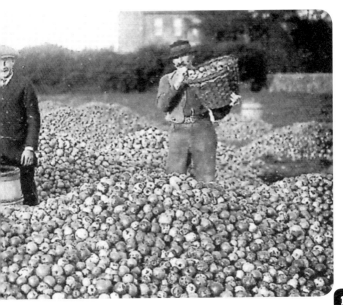

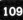

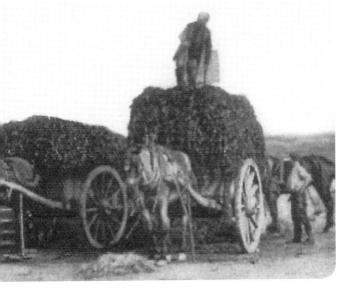

Sport

Muratti

This annual competition has been held since 1905 when Edward Lander, an agent for Muratti cigarettes, suggested a football tournament between the Channel Islands. Inter-island rivalry reaches its height during the match and violence is not uncommon.

Siam Cup

The annual Rugby Union competition between Jersey and Guernsey. First held in 1920, it is the second oldest rugby honour after the Calcutta Cup. The cup itself is made from Siamese silver and was presented by the King of Siam to Lieutenant-Colonel Forty, who was stationed in the country, as a token of their friendship.

Island Games

Held every two years, the participations come from small-island communities all over the world. In the fourteen games between 1985 and 2011, Jersey has won a total of 418 gold medals.

Jersey Marathon

Annual race that goes through the town and country lanes of Jersey.

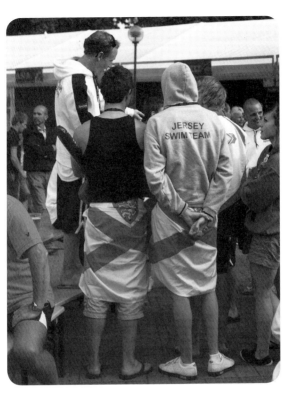

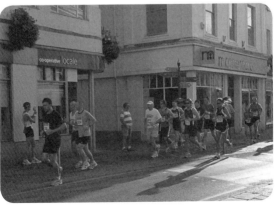

Reintroducing...

Durrell Wildlife and the National Trust for Jersey are working on restoring the heathland areas of Jersey's coastline with the aim of reintroducing species that have not been seen in Jersey for over 100 years.

They include the red-billed chough, yellowhammer and cirl bunting.

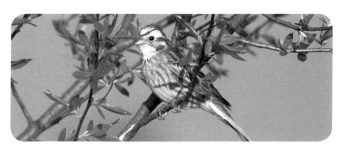

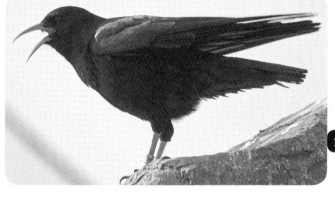

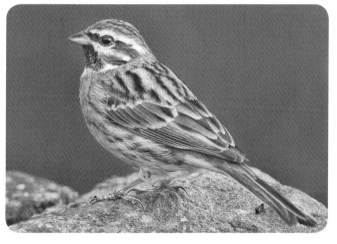

Active Jersey

Sea kayaking – A great way to explore Jersey's bays and sea caves.

Surfing – Surf in the cleanest beaches in the UK.

Bodyboarding – Great fun for all the family.

Blokarting – Get powered along by the wind at St Ouen's Bay.

Zorbing – Roll along the beach in a giant hamster ball.

Coasteering – Scramble along the cliffs.

Kitesurfing – A cross between surfing and flying a kite.

Arial trekking – Unleash your inner monkey with the 8-metre high assault course at Creepy Valley Adventure Centre.

Scuba diving – Explore the clean waters and shipwrecks around Jersey's coast.

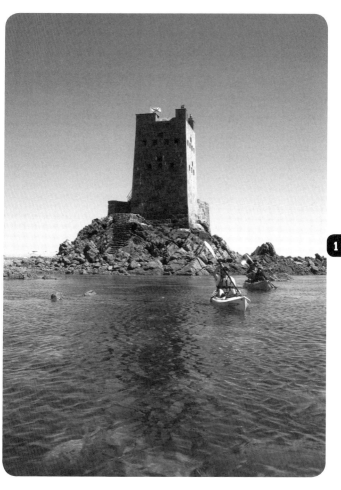

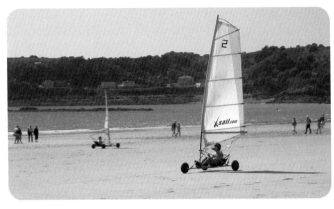

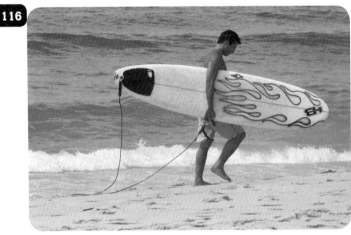

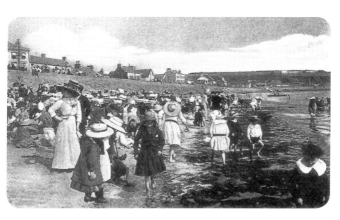

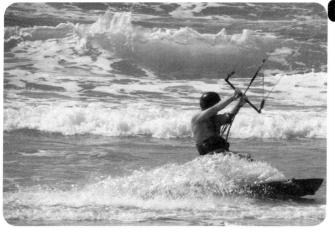

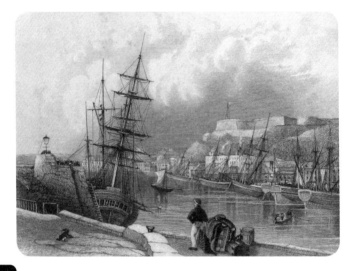

Past and Present

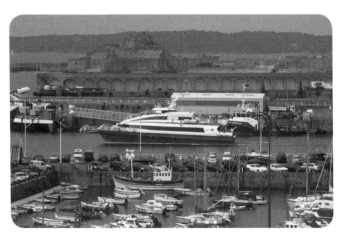

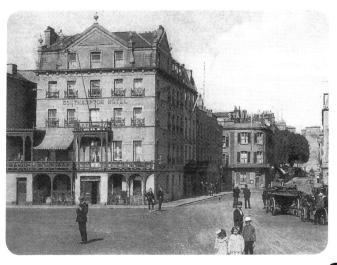

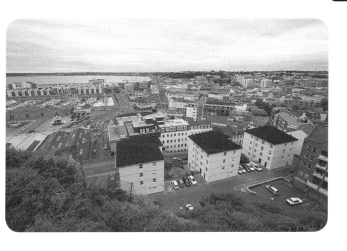

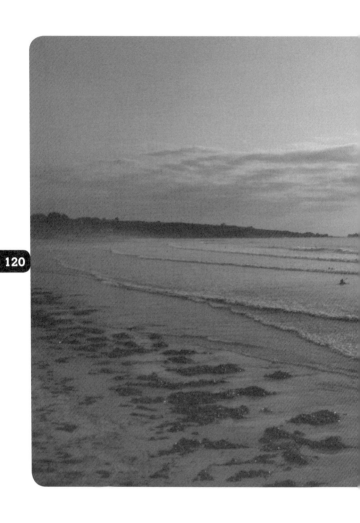

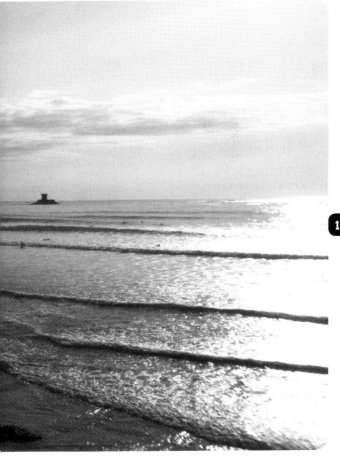

Checklist

Get lost in the aMaizin! Maze. ☐

See one of the world's finest orchid collections at the Eric Young Orchid foundation. ☐

Visit Durrell Wildlife, home to more than 1,400 mammals, birds, reptiles and amphibians. ☐

Admire the medieval wall paintings at the Fisherman's Chapel. ☐

Have an ice-cream while gazing at Corbière Lighthouse, built in 1873. ☐

Be moved at the Jersey War Tunnels. ☐

Learn to surf at St Ouen's Bay. ☐

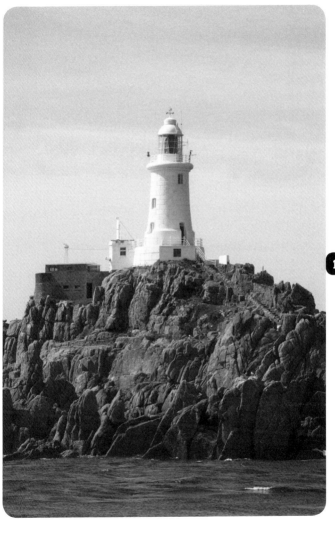

Websites

www.jeron.je

www.gov.je

www.thisisjersey.com

www.jerseyheritage.org

www.nationaltrustjersey.org.je

www.jersey.com

www.theislandwiki.org

www.durrell.org

Picture Credits

Page

Credited pictures from Wikimedia Commons with sharealike licences. Many thanks to all the photographers involved.

63. Radio tower; German bunker

65. Ecrehous (Peter Coleback); Kayaking off the Ecrehous (www. jerseykayakadventures.co.uk)

67. Plemont, *c.*1919; Beauport

69. Royal Bay of Grouville; Bonne Nuit

71. Howard Davis Park; Sir Winston Churchill Memorial Park

73. North Coast; North Coast

75. Agile frog (Gretaz); grass snake (Darius Bauzys)

77. Red squirrel; Manx sheep (geni)

79. Oystercatcher (Andreas Trepte)

83. The Royal Square by Philip John Ouless; stocks

85. St Aubin's Fort by Robert Mudie

87. Bouley Bay; St Peter's Valley by J. Stead, 1809

91. Chicks (Waugsberg); Jersey heifer

92. Fisherman's Chapel (Alex Brown)

93. La Rocco Tower (Dan Marsh)

94. Waterfront Development (Dan Marsh)

95. Cyril Le Marquand House

97. Red Arrows (Tomhab); Liberation Square

99. Hermitage by Philip John Ouless, 1852; Pilgrimage on St Helier's day (Man vyi)

101. Wace, by Sir John Everett Millais; Plaque for Jean Chevalier; Harry Vardon

103. Knight at Mont Orgueil

105. Plaque for Victor Hugo; Charles II's coat of arms at Mont Orgueil; tourism poster staring John Nettles (Jersey Tourism)

107. Jersey wonders; cider crushing (Man vyi)

108. Collecting cider apples, 1910

109. Gathering Vraic (seaweed)

111. Jersey Swimming Team, 2009 (Fanny Schertzer); Jersey Marathon

112. Red Billed Chough (Ross Elliott); Yellow Hammer (Andreas Trepte); Cirl Bunting (Bogbumper)

115. Kayaks off Seymour Tower (Jerseykayakadventures.co.uk)

116. Blokarting at Ouaisne; surfing (John Rex)

117. Edwardian bathers at West Park; Kitesurfing (Amir Gluzman)

118. St Helier Harbour 1840; St Helier Harbour today (Dan Marsh)

119. The Weighbridge, *c.*1910; The Weighbridge today

120-121. St Ouen's Bay

123. La Corbière Lighthouse

125. Ship's engine